calm calligraphy

Mãlleus

calm calligraphy

Practice Lettering to Find
Inner Peace

HARPER
DESIGN

An Imprint of HarperCollins Publishers

First published in 2017 by Mondadori Libri S.p.A., Milan

HarperCollins books may be purchased for educational, business, or sales promotional use. For information please email the Special Markets Department at SPsales@harpercollins.com.

Published in 2018 by
Harper Design
An Imprint of HarperCollins*Publishers*
195 Broadway
New York, NY 10007
Tel: (212) 207-7000
Fax: (855) 746-6023
harperdesign@harpercollins.com
www.hc.com

Distributed throughout North America by
HarperCollins Publishers
195 Broadway
New York, NY 10007

ISBN 978-0-06-279738-4

Library of Congress Control Number: 2017949340

Printed and bound in China

First Printing, 2018

*Many years ago, my parents and my siblings brought me up, teaching me a love
of simple and indispensable things, instilling fire and passion in my life.
Thanks to my family I have known true, unconditional love, the love that gives without
asking, which lightens the burden with a smile. To all of them, thank you.*

Preface

The soul has all the answers it needs, but often we don't know how to find them – hidden as they are by layer upon layer of thoughts, reflections, rationalisations. It talks to us, but quietly, in a voice as delicate as a whisper. On the contrary, the mind insists on being heard and obeyed: it gives orders and tugs at us as soon as we venture beyond the tracks of the everyday.

But we are different from our habits, from the organisation that we bring to family, work and home. We are different from all those noisy thoughts that the brain ceaselessly formulates. Above all we are different: above all we are our souls.

When I was a child, my brothers and I had no toys. For Christmas we were given a basket containing some very good cakes made by our mother and two or three mandarins brought by our grandmother. My brother Bruno and I waited with trepidation the following day, to go and pick up the old broken toys that the rich children of the village had thrown away; we brought them to the barn at our house, and there, with a screwdriver and a pair of pliers, we took them apart. I was six, Bruno was nine. We opened them up and tried to find the problems, then we fixed them, one by one.

It was then that I learned the great power of manual work and intuition. Every toy contained within it everything it needed to work; you just had to get in there, then be creative, within the rules established by the materials and their structures.

Gestures – all gestures, even the most banal – if performed calmly, lovingly, attentively, are a language that slips beneath the radar of consciousness to go directly to our spirit. They are a way of contacting our soul; to take care of it, to help it to grow and flourish.

Writing in a beautiful hand may seem strange to you at first. Your hand will have to familiarise itself with new movements, your mind will have to calm down to be able to memorise them. The first steps will be uncertain, the first letters distorted versions of the original, but even if only for a few seconds your thoughts will fall silent and you will be able to savour the most precious gift of the work of the copyist: silence. Each day you will take a step forward. And every day you will be able to enjoy moments filled more and more with inner joy. And in the end you will reach the answers: with discipline, constancy, concentration, performing a gesture as rhythmical as a dance.

Within you there are no gear-wheels to be switched around or parts to fit, but a soul that deserves to be listened to. It's all there already, like a hidden treasure chest: *Calm Calligraphy* is the map of that internal journey.

In te ipso veritatem quaere
(Seek the truth inside yourself)

I was lucky enough to be born into a family that was very poor but rich in artistic gifts. That's how I grew up: in humility and creativity. Both indispensable gifts for the copyist. My father was a railway signalman, but when he picked up a pencil and paper he could draw faces with photographic precision. My mother could take a rag and a few coloured threads and turn them into a composition as sumptuous as a miniature painting. My sister Milvia, the oldest of us, was a poet; my brother Ferdinando is a painter; Bruno was a musician.

In the summer I didn't go and play with my friends – I went to work with the village craftsmen: one year with the blacksmith, where I learned to forge iron; one year with the carpenter, who taught me to work wood; I spent one year alongside the bricklayer, another with the electrician. During those months I learned so many of those trades that today I can cope with any practical problem that arises. More than anything else, though, I know how things are built from nothing: I have no trouble giving concrete form to an idea or giving life back to an object. Furthermore, during those childhood years, fascinated and stimulated by the inclinations of my relatives, I developed not only my manual skills but also my artistic talents.

I'm a composer and a multi-instrumentalist. From my brother Bruno I learned how to play the guitar. On the organ and the piano, on the other hand, I'm self-taught: I practised secretly, hiding from the sexton, on the organ in the church of Albacina, in the parish of Fabriano, near Ancona, where I lived. When he caught me he gave me a thrashing; I

went home and confessed and got thrashed again. But after a few years I became church organist! And a few years after that, apparently quite naturally, I learned the drums and the mouth organ.

I liked school. The practice of writing with a pen and ink was a thing of the past by the time I entered middle school: students a year younger than I had never done it; they had only ever used ballpoint pens. Obviously I did the same for day-to-day writing, but throughout my years at primary school I had been ink monitor: while I performed the ritual operations – pouring the envelope of black powder into a huge bottle, adding water, stirring, then filling the pens of all my classmates one by one – I felt like an alchemist who had been given the formula for transforming base metal into gold.

In upper school I studied to become a chemist, the perfect course for a little boy who had prepared ink and taken things apart since his earliest years. Knowing about chemistry enabled me to go back to the origins of the elements and reveal their mysteries, to understand in depth the mechanisms of their combinations.

I have always written well. My little notebooks, which I enriched with drawings of alembics and test tubes and formulae written in beautiful handwriting, were so neat that they were passed around the whole school. And in 1980, when I got married, I made one hundred and seventy invitations by hand, returning years later to pen and ink. Then I opened a recording studio, the first one ever in Le Marche. It was a terrific success: musicians came from all over Italy; I worked well into the night. However exhausted I was, I couldn't wait to come home and write. One hundred and seventy cards and envelopes in English cursive, with sepia-coloured ink, and a miniature in pastels on the bottom right, reproducing a little house with the address of the reception.

The invitations were a great success. I enjoyed creating them so much that I came up with the idea of opening a workshop to make them by hand, but I already had a job, and I liked it. But I jotted down – in beautiful handwriting – the idea I had in mind, with all its details, including the name of the workshop and a sketch of the trademark, and put the piece of paper in the third drawer of my desk, where I still keep my important documents and my notes for future projects. It stayed there for eight years.

In 1988 life broke my heart. I have no other words to describe how I felt when my brother Bruno died, when he was working for the police force in Fabriano. I hit rock bottom. Even

if I had wanted to I wouldn't have been able to focus on work: the recording market in Italy had started to go downhill some time before, and was about to enter a crisis from which it would never recover.

While everything was collapsing inside, I understood that the only thing I could do was to look inside myself. My motto is and has always been '*In te ipso veritatem quaere,*' 'Seek the truth inside yourself.' When life puts us critically to the test, when we are called upon to confront very delicate situations, I think this is the only direction towards which we must turn our gaze. The answer we can give to the world lies inside us, and inside us is the next step we will take. We must make our discoveries by ourselves: no friend, no relative, however close, can hold us by the hand and give us advice during our inner search.

During those difficult times I chose the life that corresponded most closely to me: I sought the truth *in me ipso.*

I withdrew into the hermitage of Santa Maria dell'Acquarella, a little church in the mountains with a tower and a sacristy.

I was there for ten days, my only company that of the forest, the birds and the stream that runs beside it.

I have beautiful memories of that time. I spent hours meditating, seeking silence and, through it, clarity. I sat in a comfortable position and breathed gently through my nose until my mind had calmed down.

The noise of our thoughts is so loud that it drowns out the subtle, delicate message of the soul. It is as if our consciousness and our soul are on opposite sides of a street: they can see each other, but running between them are two carriageways of cars and buses all sounding their horns. We can see the soul talking to us, but we cannot understand what it is saying. Meditation lets us stop the traffic.

Then what emerges is silence. At first it will last only two seconds, but the next day those two seconds will become four, then ten, until, with regular practice, you can remain in silence for as long as you wish. Then you will be able to listen to your spiritual side, receiving in return the replies and intuitions you were looking for.

During that retreat, as if watching a film, I saw myself very clearly in my office, opening the third drawer of my desk. I was looking for a precise piece of paper among the many it contained, and once I had found it I set it resolutely down on the desk, as if to say, 'You

see?' The paper striking the desk woke me up, but not before I had read the words at the top of the page: 'Antica Bottega Amanuense.'

I had no way out. The vision was too clear to allow for any misunderstanding.

I came down from the retreat sure of the message that I had received and what I had to do, but I immediately encountered a problem. It was the late 1980s, a period of great technological change: computers, faxes, printers and colour photocopiers were suddenly everywhere. I came home after ten days of meditation and triumphantly told my family that I was going to open a copyist writing workshop. They thought I had lost my mind. I acknowledge that the idea might have sounded eccentric, at a moment in history when technology was taking a great leap forward, but I was so sure that this was my future that I pursued it with great determination, allowing no hints of uncertainty to filter through.

Fear, if it takes hold of your initiatives, is a guarantee of failure. It is a sly enemy, because it acts on the input of ancestral mechanisms of which we are often unaware. Even when you have decided to introduce something new into your life, your brain will tend to bring you back little by little to the starting point, to the status quo, because it is a condition that it knows, which it finds reassuring. It is afraid of the unknown: this is the reason why we prefer to remain in familiar situations, however depressing or exhausting they might be.

The mind is an extremely powerful recorder. It captures, instant by instant, all the stimuli it receives from the senses, from our time in the womb onwards. It is an instrument of incredible efficiency, which allows us to find our bearings in the world with relative certainty rather than feeling lost like little boats in a stormy sea.

But if life confronts us with a new situation, or if we ourselves decide to embark on a new enterprise, the mind will be able to advise us well only up to a certain point, because it cannot produce answers different from the ones it has acquired by experience. It will dart around at great speed among the countless bits of archived information (computer people would say that it's scrolling through the whole of the database) in search of reference points, analogous events that have happened in the past. It will remind us what happened in similar situations, and invite us to behave consistently, but it won't be able to give us innovative solutions to unknown problems. If we try to deviate from that, that's when fear steps in again. We find ourselves thinking: 'What am I about to do … Do I really have to subject myself to all this effort? And what if it doesn't work? How am I going to look

then?' It's a natural, understandable reaction. If we have made up our minds to set off along the path of change, however, we have to make even more of an effort. We need to search elsewhere. That's why silencing the mind is important: to let the subtle message of our spiritual side emerge.

That's what I did in 1988, receiving a very clear image in exchange. Now the only thing I had to do was give form to it. I knew it would be the right path, but given that the people I loved, the people around me, were bringing messages of fear along with them, I decided to wait for another sign before going ahead. If I didn't receive one, I would put the idea of the workshop back in the third drawer for the time being.

A few days later Gaetano, a very dear friend and an outstanding graphic artist that I hadn't seen for many months, came back from a long journey and gave me a package as a present. I opened it: inside was my first pen with a flat pointed nib. It is an implement used only for formal writing, with which the scribe, regulating the angle of the writing and the direction of the line, can make marks of very different thickness. You can imagine my joy at the sight of such an unequivocal sign.

Strong in my vision, encouraged by that gift, I decided to carry on. I had always written, that is true, but I had no specific training in the subject. I was like a graffiti artist who wanted to start painting on canvas. The first step was to resume my studies.

I remember that passionate and constructive time with love and nostalgia. By day I went on working in the recording studio, but I couldn't wait to get home and start writing. I experimented with different types of paper, different types of ink. I read calligraphy manuals and made my first attempts at working with gothic script. Looking back, with almost thirty years of experience, I see that my work was limited in all kinds of ways; but at the time those letters looked beautiful to me, even if they were all distorted and irregularly spaced. The callus on the hand, a necessary evil for all professional calligraphers, caused me problems, it hurt, but I didn't care. I was learning and was happy to do it. I was inspired, immersed in a new vision of life and the future. When I talked about the Workshop I was already using the word 'we,' because I already knew that one day I wouldn't be on my own. As I became more disciplined, my handwriting improved. But after two years I realised that, studying in solitude, I wouldn't be able to get any better. So I went in search of a teacher. I didn't want to risk learning to write badly – a worse possibility than not learning anything

at all: correcting a shortcoming, in fact, is more difficult than picking up something new from scratch.

The last Italian copyist lived in Bologna, but he was very old and not taking on pupils. So I went and looked abroad. In meeting the great experts I particularly enjoyed the return to humility: going back to feeling small when faced with such masters was very constructive. Christopher Haanes taught me the humanist scripts of the fifteenth century, Giovanni de Faccio gothic, Thomas Ingmire chancery, James Clough English cursive. Thanks to Donald Jackson, the official calligrapher to the Queen of England, I learned a great deal about the art of the copyist and about embossed capitals. Last of all, Michael Harvey taught me the techniques of carving in stone with a hammer and chisel. I have studied with the best masters of my time, learning not only to write but also to make miniatures and decorations, and to produce inks.

Today I'm the master. I have twelve students and my workshop is the biggest scriptorium in the world. We work in a castle not far from Recanati. My office is at the top, in the tower, surrounded on all sides by windows that let the light flood in.

Is becoming a copyist an unlikely dream? Perhaps. But it was my dream. I could tell you that I realised it by writing and it wouldn't be a lie. The rigour and constancy that are indispensable for learning to write are the same as the ones that enable you to silence your mind and approach your own spiritual side. For me, writing is a way to listen to my soul, just like meditating.

Over the years the two practices have become an indivisible whole: I don't think it's a coincidence that together they have enabled me to make my vision a reality and turn me into the man I am. In these pages I don't propose teaching you to write like a good master would do, correcting you as soon as you deviate from the outline and forcing you to linger in search of perfection.

Instead I plan to open the doors to my world, a world overflowing with legends, in which magical things happen, and share with you the poetry of a tradition thousands of years old that I am trying to project into the future.

I want to offer you the opportunity to experience the same emotions that I did when I was setting up the Antica Bottega Amanuense. The deep significance of our existence on this earth, in my view, lies in the emotions that we have: if we neglect those, if we don't take care of our souls, we risk not knowing where we are going. We risk stopping.

It isn't easy to remain aligned with your own spiritual side: we tend to part time as if it were a cloud, concentrating entirely on escaping the past and throwing ourselves into the arms of some hypothetical future that awaits us. The fact is that nothing awaits us but a sequence of the here and now, which we lose sight of. We only realise this when we manage to stop, to be amazed by the sight of a swooping hawk, a mountain at sunset, the smile of the person we love.

This book is an invitation to stop, to seek beauty in the line, training your hand to execute unfamiliar movements, in a slow and disciplined way. It isn't important for you to write very well, just for you to write. If you manage to respect the seven rules I give you in the following pages, you will be able to make contact with silence, and give yourself time to hear the clear message of your soul.

The seven rules

The first rule: establish the limits of your sacred space

You will have to carve out a space and time just for yourself, away from the constant flow of tasks that you are immersed in. This will be your sacred space.

It doesn't take hours: it might take only fifteen or thirty minutes. The best thing would be to set aside a few minutes every day, but I realise that isn't always possible. But you have to be consistent: once you have decided when and where you will write, you will have to make an appointment with yourself and keep it.

Then my advice is to protect your space from any kind of invasion. Other people (including the ones you love and who are part of your life) will not be able to reach you: ask them not to disturb you. You will also have to shut out haste, shopping lists, your ringing phone, your computer bursting with emails. They will knock on your door; you will have to ignore them or send them away, and isolate yourself. That way you meditate, that way you write.

According to the Knights Templar, man is in balance when body, mind and spirit are aligned – when, that is, you dedicate equal attention to the earthly and spiritual worlds.

To explain this concept they use the metaphor of the balance. Imagine that your neck is fixed to the central pivot and that it can move back and forth according to the movement of the horizontal arm, to which two dishes are connected. Your face is turned towards one of the dishes on which the weight of the material world presses down, forcing you to walk with your head lowered. You can hold your neck straight for long enough to sidestep

obstacles on the ground and see where your next steps are taking you, but you can't see beyond that; you can't have complete vision.

To stand up straight and lift your eyes you have to counter-balance that weight, dedicating time to your inner journey. Every meditation session, every moment dedicated to introspection, every half hour of calligraphy that you choose to engage in will be a little grain of sand that you place on the dish to the rear, the one dedicated to spirituality. Over time everything that is everyday and concrete, everything that now seems so heavy – problems, worries, never-ending haste – will seem lighter to you. If, like one of the Knights Templar, you manage to achieve the perfect alignment between body, mind and spirit, you will be able to intercept events before they happen and help others to travel the same path.

I know it isn't easy, but that doesn't mean there's no point in trying. People might disturb you: they will call you, knock on your door, make the phone ring. Your mind will do the same, producing an incessant noise. If you have a problem on your mind, it will present itself to you continuously, uninterruptedly, making you feel guilty because you are frittering your time away on things that seem pointless to you, and you are not rushing to where you 'should' be. Relax: you're exactly where you should be.

Gripped by the enthusiasm of all new initiates, you will keep the first three or four appointments, then your mind will lead you to postpone them, finding excuses.

Many years ago, every evening I recorded memories and emotions in beautiful handwriting in a diary. The first few pages were wonderful: they reflected my sensations as I wrote them down. The ones that followed were a little careless: I was experiencing the assault of the mind, which underlined the uselessness of this activity, however pleasurable, and reminded me how many other pressing tasks awaited me.

It was my ego talking. If you pay attention, you will notice the ego hates not to be consulted. Even more, however, it hates it when you feel pleasure in pursuing an activity that the ego has not decided upon. For a while it lets you get away with it, then very gradually it brings you back to the previous state without your being aware of it. The temptation to yield to the flattery of the ego, which makes us feel that we are needed elsewhere, is very strong. Not least because as a rule it offers a solution that is in every respect compromised: 'Not now, but the next time.' Except that 'the next time' never comes. Changing the mind-set

that conditions you to live always on the run is indispensable if you want to find yourself. To do that you will have to persevere.

I did it, and the next few pages in my diary are even more harmonious than the first. Because I was blissfully lost in writing, cut off from all outside contact. In my inner silence, I forgot where I was and what I was doing. I heard the nib scratching on the paper, the pungent smell of ink, and I watched my thoughts becoming real, through the signs that were being produced in front of me. I was immersed in my sacred space.

With reference to meditation the verb 'practise' is used, and not by chance: whatever you are talking about – playing an instrument, writing or dancing – to train yourself you need to practise constantly. The results come in, but day after day. I assure you it's the same with meditation. If you keep at it, the ego will give up. One morning you will get up to go to work and you will be happy because you will know that this is the day when you will write as soon as you come home. It will be the same mind that remembers, because it too will have learned to find pleasure in silence.

I would like you to be able to have a similar experience, because from that moment onwards you will be able to find realignment with yourself.

There are plenty of theories of meditation: they all offer methods for attaining inner silence. Knowing how complicated it is to reach it sitting there in silence with your eyes closed, I'm suggesting that you practise it starting with a gesture, a real and tangible act that requires concentration and provides aesthetic satisfaction. These are movements which are unexpected, alienating, which you will have to execute with your eyes wide open: writing as the scribes used to do requires more than just movements of the fingers, like when you are tapping on a keyboard or a tablet – it requires the concentration of your whole body. It will be your whole body that takes care of your soul.

The secret of this method lies in the difficulty of calligraphy: applying yourself in a careful and critical manner to the execution of a word is a way of distracting your mind, making it silent. In inner calm, the voice of your spiritual side will be able to emerge, and you will be able to pick up its message.

The second rule: breathe and take up your position

You are in your sacred space. You've told everybody you're not taking calls. You've closed the door, switched off your phone and sat down at the desk with the book in front of you. Don't rush to open it at the page where you put the bookmark last time.

Take the time to tell your brain that you're no longer in the flow of the everyday. Prepare your body for the most beautiful journey you will ever take and your mind to receive new stimuli.

Close your eyes. Spend a few moments collecting yourself. It is no coincidence that for centuries copyists have stayed silent while they work, and that silence must remain sovereign in their libraries.

Breathe deeply two or three times: fill your lungs, breathing through your nose, and enjoy the sensation of peace that it gives you. Let it spread within you like warm sunlight and fill all the available space.

Now, open your eyes and take up the position.

Your posture is extremely important. Scribes have said: '*Tres digiti scribunt, totum corpus laborat*' ('Three fingers write, the whole body works'). The line produced on the page is the final result of the synthesis of an effort and a complex discipline: it is not possible to respect spacings and inclinations or obtain aesthetically commendable marks by fidgeting in your seat and constantly changing the orientation of the page. Each movement you make will influence the writing, particularly movements of the back and shoulders but also of the legs, particularly if you sit cross-legged.

During their apprenticeship, copyists learn to write standing up, on an angled table. You will probably be sitting at a desk, so you will have to make yourself comfortable, with your back straight and your shoulders relaxed: not bent but not as stiff as a puppet either. The axis of writing must be aligned with your body: the page will be in front of you, moved slightly in the direction of the hand you use to write. 'Slightly' does not mean thirty centimetres, but four or five, so that your working area is fully inside your visual space and doesn't require an effort to comprehend.

You probably don't have a professional implement like elbow nibs, which I will discuss in a few pages, so you will have to rotate the page by about twenty degrees – towards the left if you are right-handed, towards the right if you are left-handed.

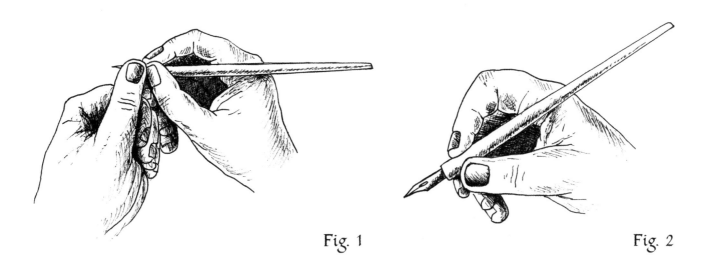

Fig. 1 Fig. 2

Now pick up your pen or nib. Remember: '*Tres digiti scribunt.*' Rest the penholder between the second and third joints of the middle finger and hold it with the thumb and index finger without gripping too hard, delicately: you will have to exert just enough pressure so that it doesn't slip away from you. Then check that your fingers are neither too close to or too far away from the tip: the right distance is that of the width of your thumb, like in the drawing, where you see the tip of the nib protruding by 3–4 mm (fig. 1).

This position of the hands, and the right hand in particular (fig. 2), is universally recognised as a method of channelling the flows of energy that emanate from each of us. It appears in all religious iconography, both Western and Oriental. For centuries Christianity painted the fingers of the saints like that, alluding to the union of earthly nature with divine nature, and those of Jesus, who blesses us in this way. We encounter the same position in the Far East, in the *mudra*, ritual gestures of the hands typical of Buddhism and Hinduism. The Buddha, for example, brings his fingers together in the *vitarka mudra* (a posture which encourages the transmission of spiritual principles). The yogic position of the Brahmin (the classic in Eastern meditation), with the legs crossed, the back straight and the hands resting on the knees, requires the last three fingers to be extended and thumb and index finger to touch one another, united in the circle of the *gyan mudra*.

The third rule: be emotional

Turn on the radio. How is it possible that the music and the voices of the DJs travel through space until they enter your house or your car? It happens via a carrier wave – the vehicle which transports the signal from its point of origin to the points of reception, where it is intercepted thanks to frequency modulation. Without a carrier wave the signal, however powerful, could never arrive anywhere.

Without it, nothing happens: everything remains unchanged, the days pass, the conviction of living in an immutable reality becomes fixed. If you have an ambition, but you pursue it without determination, distractedly, you are wasting your time: any enterprise you attempt will be a failure. To make your desires a reality you must count on the support of an intense and positive emotional state, a luminous state of pleasure: in other words you must perceive them as already present in your life and walk towards them without ever detaching from them the umbilical cord of your emotions.

Prophecies are self-fulfilling: it's not just me saying that, it's thousands of years of literature, beginning with Greek mythology and all the way to sociology and psychology. Do not flee your own emotion. You can repeat every morning that you really want to get your degree, but if you are not one hundred percent convinced within yourself that you can do it you will never attain that degree, or only with a huge amount of effort. You can swear that this evening you will carve out your sacred space and devote yourself to writing, but if part of you thinks that what you are writing is the ravings of a copyist too accustomed to being bent over his books, you will find an excuse and dedicate yourself to something else.

Life will always lead you in the direction traced for you by your emotions: that is why it is important to tame fear, and also melancholy and victimhood. If you think you are destined for perennial disappointment, and your emotions are based on the sorrow that follows from that, life will always bring you back to that same place, ensuring that you feel that sorrow again and again, offering you a thousand and one opportunities for disappointment.

This is a kind of unavoidable law, but it is not a labyrinth from which there is no way out. The philosopher Jiddu Krishnamurti has written: 'We change ourselves to change the world.' I think about those words a lot. We feel we are in thrall to a universe governed by

principles bigger than we are, forgetting that we are the ones who give form to our lives, both positively and negatively, directing the energies that move it. If what we desire is change, it must come from us: no one will send it in our place. On the contrary, once we have sparked it, it will be reflected in the people who are close to us, involving them in an irresistible spiral of positivity.

'And I'm supposed to be able to do all that by writing?' you will be wondering as you read these last lines. No, of course not. Writing isn't enough. But realising your dreams through writing is possible, as long as you maintain them with a carrier wave: the wave of your emotions.

Let me tell you an anecdote, another one that comes from my life. In 2005 the Antica Bottega Amanuense was growing, and in order to help it do so I was looking for even bigger, more light-filled spaces than the stupendous ones in the Villa Colloredo, in Recanati, where it was based at the time. I spent months looking for the perfect place: I visited villas, old palaces, farmhouses that needed renovating … none of them seemed to be the right one. As I usually do in similar cases, I decided to interrupt my exploration and take some time to reflect. Perhaps I couldn't find the right building because none of them corresponded to what I had seen in my dreams a few years before.

I had set off at dawn, in a coach, following a group of winemakers from Conero heading for the Salone del Gusto in Turin. I designed the labels for the bottles of one of the wine-makers, and still do: going with them struck me as an excellent idea; I would be able to meet lots of other artists and illustrators. We had stayed up late the previous evening. By the time we reached Rimini South I had fallen asleep; but by the time we got to the exit for Rimini North I was already awake. I had slept only for a few minutes, but more than enough to have a clear and detailed dream: I was flying around and inside a big building, a medieval tower flanked by two crystal wings. In that place I felt at peace, creative and calm: I explored it in depth, from the terraces to the basements, the drawing rooms to the foundations; then I flew up to find out where I was, and at that point I was awoken by a feeling of dizziness. I immediately picked up a notebook and jotted down all the details I could remember. Two months later the picture of Màlleus Castle was ready: a dream too great even for me. In fact I left it in the third drawer of my desk for years, and I allowed myself to revisit it only if I hadn't found a convincing alternative.

I've mentioned the emotional carrier, and now I will explain to you how I put it into action.

Day after day after day I gave shape to my vision and my wishes, adding details each time. I wanted to build a castle, so I drew up the location plan, I visualised the design, the arrangement of the rooms, the terraces, I imagined the use I would make of every single space. I listened to the sounds that would filter through the walls, I enjoyed the light that would come in through the windows on sunny days, I went up and down the stairs, I walked along the corridors, stroking the bricks, I stopped to read the titles of the volumes I intended to put in the library. I chose the paintings I would hang, the colour of the curtains, of the floors and the walls.

Imagination has the power to show you things that do not yet exist, putting you in the state of experiencing them exactly as if they did exist. As I walked through my castle I felt a sense of joy, of satisfaction: those emotions were real, exactly like the ones I would feel if my project had already been realised.

In the case of Màlleus Castle, visualising it already built was not a problem: everything was so clear to me that I had already drawn it. Not even the carrier emotion had created difficulties for me: I was in love with the idea of building it. The thing that concerned me was the fact that its location was unknown to me. The only aspect I had been unable to bring into focus during my dream: where would it happen?

Like any decent castle, this one too is the main character of a legend concerning its origins. It is said that in 1405 a monk placed on parchment the precise position of a clearing near Recanati where he was pitching camp. In the morning he thanked God for the relief He had given him from his chronic pains, the recovered sense of well-being and the inner peace he had felt there. It was in this spot where, in olden times, a fortress had been built, then destroyed, all around the crater left by a meteorite. Having found the document, it took me a few weeks to match the information that it contained with contemporary maps. One evening, at the end of August 2006, I drove close to a ridge just below Recanati, took a run and reached the top. The view took my breath away: the ground sloped gently, one hill after another, down to the sea. In the sky was the light of the moon and the stars. It was the same horizon that Giacomo Leopardi had loved before me ('In this immensity my thinking drowns/and sweet it is to be shipwrecked in

this sea') and, with it, thousands of people whose names history does not record. I sat down on the grass. The only sound was the song of the crickets. I touched the ground and felt it vibrating with the same energy felt by a mysterious monk in 1405: an energy that brought peace, freedom, joy. I had found it: it was the place I had dreamed of, and it was there that I laid the first stone of the castle.

Fascinating though it might be to have discovered this place thanks to a dream and an ancient parchment, a refined study of sacred geometry or who knows what else isn't really important. What matters is that each one of us has the ability to change the direction of one's own life. Quantum physics teaches us that we are moving towards levels of reality that correspond to our emotions: we can make for a castle that is already beginning to take shape, or towards a scenario that no one can imagine. The choice is up to you. You too have that power: by writing, you will learn to channel it, to feed it, to develop it.

The words I will invite you to write in the second part of the book have not been extracted from the dictionary at random. The scribe monks loved to give themselves the task of putting positive concepts in writing, so that they would be carried into eternity: 'You are the bearers of the words. The worthier they are, the more they merit your effort and your skill,' they said, 'because writing will make them immortal.'

'Harmony,' 'strength,' 'gratitude,' 'love' ... all are words of light: approaching them line by line, letter by letter, they will enter you, and you will enter them, vibrating in harmony with their deepest essence. My intention is for you to be able to resonate with them, amplifying the emotional wave with which you will accompany your desires towards their realisation.

Could I have selected others? Certainly, if I wanted to act out the role of master of calligraphy with you. From a technical point of view there is no difference between writing 'fear' and 'joy.' From a spiritual point of view, however, there is a great chasm. My goal is to do everything possible to connect with the positive energies within you, to allow them to flourish, listen to them and actually set them down in black and white, thus giving them fresh force.

The fourth rule: be disciplined

As a rule, every time I talk about 'writing' I am alluding to the copyist's writing which, to be exact, consists above all in copying out words or texts of various lengths. I will begin by making some basic letters, to give you confidence with the rhythm of this kind of writing and familiarise you with the new implements, if you have decided to buy them. Then I will move on to copying out words; and finally I will give you the opportunity to enter into brief and happy compositions that have inspired me on many occasions. Apart from Leopardi and Krishnamurti, you will find sentences from Horace, St Augustine, St Thérèse de Lisieux, Zhuang Zhou …

To do this kind of writing you need to be disciplined not only in terms of time, keeping your appointments with yourself, but also in a technical sense. It will be immediately clear to you that to learn English cursive you must follow a set of rules that guide the hand to obtain an aesthetically pleasing result: you will have to analyse my examples, pay attention to the construction of the letter, the spacing, the slope of the writing. If you decide to use a nib you will have to learn to balance the pressure of the hand on the page to obtain thinner or thicker lines: in fact it is in the harmonic difference between these thicknesses that the beauty and elegance of English cursive lies.

Your first attempts will be a little awkward and uncertain, then you will acquire greater confidence and, after copying a word many times, at the bottom of the first page you will at last see something that resembles the original, and you can be satisfied with your first day's work. You will close the book and plunge back into the business of your life, but taking with you the positive energy you experienced within your sacred space. By the time you approach the second page you will already have a minimum of experience, and you will begin with the mistakes you have committed: you will look critically at the work you have already done, concentrate on the new word, observe it line by line, and what you trace on the first line will already be better than the last one from the previous session.

I don't want to seem like too strict a master, but you only reach your own goals if you apply yourself in a disciplined fashion. However gifted you may be, no one who acts superficially will produce lasting results: take each day as it comes. Sometimes it will be pleasant, as long as it is a choice; if it isn't, if taking each day as it comes is a lifestyle, it

can end up being limiting: such people can find themselves in a state of crisis if they are faced with a task.

Training yourself to be disciplined is a good way to grow.

In the first place, counterintuitive as it might seem, it encourages your own creativity: having absolute freedom does not help you to challenge your own potential, particularly when and if we have many different potentials. And if we do not have a clear map of our attitudes and talents, being told that we can do 'whatever we like' does not help us to understand which direction we should take. Close analysis – any close analysis – is the result of discipline. In this case, consistently following a set of external rules will show you how to go in search of a new dimension within yourself, which you might never find if you do not impose certain limits on yourself.

Secondly, in the long run the discipline that you apply to writing will spread to the other areas of your life in the form of healing. Detached from the pervasive technology with which you are used to living, which privileges speed over accuracy, you will rediscover the importance of performing every single gesture with the greatest possible attention.

Leaving your sacred space, you will bring this way of working home, into the street, into your office: you will be more cautious, scrupulous, respectful of the time and quality of the work you are doing. This is not always an advantage: often it is temporarily handy to be distracted and turn a blind eye, but in your life, if you intend to achieve important goals, this attitude will help you to pursue them.

The fifth rule: proceed slowly

Once you have picked up the pen, don't start writing straight away: you would be doing it as you have always been used to.

Start by analysing the mark in front of you, the letter, the word. Follow it with your eyes from start to finish, slowly, accompanying the dance of solids and voids and trying to work out when and how a change of pressure leads to a change of line. Study the mark, memorise it and also draw the letters backwards, from the finish to the start, to understand even better how they come into being.

Stare carefully at the word and imagine you are going inside it, as if the line were a street that you were driving down in a car; do that time after time until you can memorise it.

It is only after you have achieved knowledge of the mark that you will be able to copy it.

Slow your hand down and work carefully, to give your mind a way to learn to perfection the gestures to be performed. Only when they have become confident and automatic will you be able to increase your speed.

The first seven or eight words on your page will be a little hesitant. Stop, go back and look at them critically: where did you make your mistake? How can you do it better? Where did you do it well?

Don't overdo your self-criticism: it is normal for your first attempts to be disharmonious. Don't lose heart: keep going. Just as you have to give your hand time to learn the gesture, you must give your mind time to internalise mistakes, correct and overcome them.

Keep going, checking the result of your work every now and again. At the end of the first page you will notice that the last words are much more elegant, balanced and similar to the original than the first.

Being hasty will not help you. Finish the page in record time and you won't win any prizes, diplomas or other results, apart from the premature interruption of your work. On the contrary, writing slowly will give you a way of suspending the crazed rhythm at which you usually move, and which seems immutable: I get up, have a shower, a quick breakfast, I get into the car, I send emails from my phone while I am stuck in traffic, I work for eight hours, taking a quick lunch break at the computer, I come home exhausted, perhaps having been to the supermarket.

This rhythm is not set in stone: if it isn't what you want, it is only right and fair that you should try and find another one.

Sometimes I have meetings in Rome. When I get south of Gran Sasso I park the car in a square and get out, even if the temperature outside is below zero, and contemplate the spectacle that nature offers me, taking my time. Does that mean I will be a bit late? Not usually, because I always set off very early, but if I was … patience. I call up to alert them and apologise for being late: because there is more life in that breathtaking vision than two hundred miles of highway at seventy-five mph with your head down.

The sixth rule: find your rhythm

As you write, concentrate. Not on the dinner you have to make, tomorrow's lunch, the new phone you want to buy: if you do that you won't write well, as all apprentice copyists know.

Enjoy the sensation of peace and concentrate on the rhythm of writing.

You will see that the letters are all more or less the same distance apart. 'More or less' because they haven't been written by computer, but by me, which means that they bear the trace of having been made by hand. Every copyist has distinctive features: the inexpert eye won't notice them, but that's how it is. As graphology teaches us, each of us writes in a way influenced by our own personality, and we therefore tend to execute distinctive, micrometric shifts that shape our writing, creating a unique variant of gothic or cursive scripts. It is these details that constitute the 'signature' of a copyist and enrich the handwriting, making it special.

Rhythm is one of those details. You will find yours in the sequence of actions you have to complete each time you start a new page – observe, analyse, study, then begin; stop, go back, start again, check, until you have a result that is pleasing to the eye and gratifying to you. You will also notice the distance between the letters: as I said, the inexpert eye probably won't notice, but the eye of a copyist will notice immediately whether the letters within a single word are positioned irregularly (some of them too close, some too far away). You will discover it, in the end, in the single letters: as in a dance, you will find your rhythm in the rise and fall of the nib on the paper, in the thickening and narrowing of the line. If you are in silence, concentrating, the repetition of the same word ('love,' 'love,' 'love,' as many times as there are lines on the page you are working on) will itself become a mantra. You will be able to dedicate all the time needed for a single page: ten minutes, a quarter of an hour, twenty minutes.

Getting used to this rhythm in writing will help you to work in time with your life – in time with yourself, with your spiritual side – even where small tasks are concerned. If you have to chop an onion, for example, you aren't obliged to chop it in sixty seconds, but you can allow yourself to reduce it to equal-sized pieces, even if that takes a few more minutes. Likewise, you can extend this attitude to all areas of your life.

The seventh rule: lose yourself

Once you have read and learned the first six rules, forget them. If you have internalised them, they will remain within you even if you no longer pay attention to them.

Enter into the word, running through it letter by letter – first with your eye, then copying it out. Dance with it, accompany its birth by sliding the nib over the paper. Let the word fill you up, let it echo inside you like a mantra, filling up all your space. Your attention will become sharper, it will become extremely sensitive: lost in the letters, you will see them forming perfectly in front of you, and in the end you will almost have forgotten that you were the one who wrote them. The word will become you and you will become the word.

That happened to me with a jewel that I was drawing at the bottom of a parchment. I couldn't give it the right light or the right three-dimensionality. I closed my eyes, breathed deeply, sought the silence inside me, then returned my eye to its shape, its reflections, the variations in its colour. All of me was concentrated on the jewel, when I found myself inside it. I visualised myself inside it, like a tiny man in a huge cave: from then on I was able to capture the perfect angles of the light and the three-dimensionality of its shape. I worked as if I were holding an immense nib. When I re-emerged, the jewel was perfectly drawn.

This book will accompany you in the discovery of your spiritual dimension. Once you have made contact with it, you will be able to look at your life with fresh eyes – eyes that are clearer, more serene, more far-sighted. You will still be yourself, but more detached from the material world, more respectful of your time, better aligned with your soul.

Try to ignore fear, rationale, haste; allow yourself to feel emotions and release your power. Change is inside you: let it free.

The art of calligraphy

Welcome, my new apprentices.

I'm not asking you to learn the gestures that copyists master over years of practice, so I won't be forcing you to copy out individual letters thousands of times until you reach perfect results, but to take advantage of this opportunity to travel on a spiritual journey. Before you start practising, however, just like a copyist you will have to take into account the fact that you are approaching an art that is thousands of years old so it will be necessary to acquire some rudiments of palaeography, the discipline that studies the evolution of writing over the centuries, and familiarise yourself with the implements that you will have to use.

The training course of a copyist

Every apprentice follows a training course lasting approximately four months. All the copyists who work in the Bottega are women, in a spirit of righting wrongs with regard to their gender, which was excluded from the Church throughout the Middle Ages: in making this choice I wanted to give women back the role that was denied them for so long.

The first phase of training consists in studying palaeography. At the same time, the student will have to become confident with her posture and with a new implement, the flat-tipped nib, and practise until she develops the scribe's callus. Perhaps you don't know that copyists can write for many hours only when they have hardened their skin at the

point where the pen rests, between the second and third joints of the middle finger and the tips of the thumb and index finger. The apprenticeship, however, follows a progressive process designed to avoid leaving the fingers painful and tired.

Once the palaeographic, postural and manual training is completed, the student begins to study first one script, usually gothic, which is then followed by the others. Once the apprenticeship in different writing styles is finished, we move from work on paper to work on vegetable parchment, the support used most frequently in the Bottega. This is no small step: on paper the resistance is greater, the nib doesn't slide as much; parchment, on the other hand, is very smooth, it is more slippery. So once the writing has adapted to the new support, following a ceremony the student becomes a copyist for all practical purposes and becomes part of the big family of the Bottega.

Outlines of palaeography

There are as many different kinds of palaeographies as there are alphabets within the science of linguistics: the one that interests us concerns the styles of writing employed by the scribe monks of the Middle Ages and then by the master calligraphers of the Renaissance.

From the second and third centuries A.D., once the shift had been made from papyrus to parchment (or vellum), and the reed pen had been gradually replaced by the quill, the typical monumental writing of the Roman age began to make way for *uncial*, a massive, rounded script typical of early Christianity. Uncial does not have ascending or descending lines, which cross the line of writing, or spaces between the letters; if you look at the pages of the first Latin Gospels you may note that the spacing is regular and that there are no ornaments apart from the occasional slightly larger capital. Uncial is anything but a quick style of writing: the need to write more quickly in everyday life gave rise to *semi-uncial*, the first script with marked ascenders and descenders. Both (uncial and semi-uncial) travelled with the Christian evangelists to the far north of the Roman Empire: there they were adopted by the monks, and by the English and Irish communities, where they assumed

the name of Celtic scripts and continued to exist in parallel with more or less informal cursive forms of writing.

During the period of chaos that followed the collapse of the Roman Empire (476 A.D.) the monks acted as links between the main European cultural centres, and watched over the emergence of new forms of writing. One figure who reimposed order was Alcuin of York, a scholar summoned in 782 by Charlemagne to run the *Schola Palatina* of Aquisgrana, making it the most renowned and accomplished in the whole of Europe. Alcuin was the intellectual that the Holy Roman Empire had been waiting for: a meticulous connoisseur of treasures that had been long forgotten, an intellectual who was able to organise knowledge rather than offer new perspectives. To him we owe the revival and revelation of knowledge inherited from the past and long hidden away. In the field of palaeography, Alcuin systematised the evolution of writing from the primitive forms in vogue in Roman times to uncial and semi-uncial, then elaborated a script for books, *minuscola carolina*, so-called in honour of Charlemagne. From monk to monk, from *scriptorium* to *scriptorium*, carolina spread within and without the Empire, becoming commonly used, just as happened with the Latin alphabet.

Carolina remained in common usage until the year 1000, when a narrower and more angular script began to develop, one which we know as *gothic*. Some mythically inclined historic sources suggest that this script emerged in northern Europe (in Germany and France) immediately after the year 1000, because of a desperate famine: convinced that the world was coming to an end, people stopped producing parchment; the scarcity of writing materials forced the copyists of the time to make their writing more compact, so as to be able to write the maximum number of words on a page. The first gothic letters, in fact, are illegible to all those who are not experts in the field. Official records put the birth of this script in the period between 1067 and 1075, the time of William the Conqueror, thanks to a document from the Abbey of Saint-Étienne de Caen in France.

Created under Norman and Angevin influence (in France and England) before spreading to Germany, Spain, Sicily and the rest of Italy, ancient (or primitive) gothic developed out of minuscola carolina and remained in favour from the late-eleventh until the thirteenth century. It was probably created as the result of a technical modification: some copyists cut the tip of their goosefeather quills straight, and no longer at an angle, thus beginning

to draw more angular and compact letters and giving the page a more vertical quality. According to place, gothic itself changed into scripts with slightly different nuances: in northern Europe it became *textura quadra*, with more rigorous and gloomy letters, and in Italy into *rotunda*, softer and more graceful.

From the thirteenth to the fourteenth centuries, with the flourishing of the arts, letters and sciences, manuscripts were in ever greater demand. The first book printed in moving characters, a Bible, did not emerge from the Gutenberg printing works until the mid-fifteenth century. It would take a long time before print became the new standard for the production of books: so there was a long period in which printed books lived peacefully with those written by hand by copyists and master calligraphers. During those years, in Italy, two Florentine humanists, Poggio Bracciolini and Niccolò Niccoli, who considered gothic artificial and hard to read, returned to minuscola carolina, 'modernising' it according to the taste of the time and creating *littera antiqua* (or humanist writing), which was used for the copying of classical texts.

With the passing of time and changes in aesthetic sensibility, scripts underwent a further evolution. *Roman chancery* is the first true cursive as we know it: sloping towards the right, elegant but informal and quick to write, it has none of the solemnity of earlier scripts. The name derives from the fact that it was adopted by the Papal Chancellery and the Court Offices for writing official documents (which is why the Anglo-Saxons, seeing these characters on documents coming from Italy, still call it *italic*).

English cursive, the script that I will be teaching you to write, is born out of Roman chancery. They are both sloping scripts: all you have to do is change your writing implement, switching from a flat nib to a pointed nib, to see English cursive taking shape. With this script you can give greater speed to your writing, while still preserving the elegance of the line. You will find it familiar because, even though it lacks the vertical elements and the slants, it is the one you were taught at school.

Writing implements

As you will have noticed, the evolution of scripts goes hand in hand with, and sometimes emerges out of, the evolution of writing implements: pens, but also supports. In all likelihood you have always written with a ballpoint pen: this is a recent invention, which comes after thousands of years of development of writing techniques.

I invite you to try to use a nib and ink as the copyists did. It is less practical, that is true, and it creates a series of problems that the ballpoint pen (and the fountain pen before it) has resolved: every now and again you have to dip the nib into ink, and if you take too much there is a risk that a drop will fall on the page; if you take too little within a few moments it is clear that you will have to start over again, with a faint mark already drawn.

From the stylus to the ballpoint pen

The evolution of writing implements was dictated by the quest for a greater practicality and speed of writing. The oldest of these is the stylus, a spike of metal, bone or wood used by the Sumerians, the Phoenicians and the Greeks to carve tablets of wax or clay. To write on papyrus, on the other hand, they used the calamus, a strong, hollow reed that held ink. It was originally taken from the stems of grasses or rushes, but the Romans also used a metal variant.

The goose quill supplanted the calamus in around the fourth century A.D., when papyrus was abandoned in favour of the more practical parchment, and remained in use for hundreds of years, more or less until the arrival of metal nibs. Light, easily repaired, fit for even very thin lines, the goose quill is, however, quite fragile, and therefore had to be sharpened quite often.

Metal nibs, made of a more durable material than goose quills, have been a tool used for study since ancient times. But they did not become widespread on a large scale until the nineteenth century, when the evolution of manufacturing processes meant that implements of the right sensitivity and flow could be put on sale.

In 1884 Lewis Waterman came up with the idea of inserting an ink reservoir inside the penholder to which the nib was fixed, thus avoiding the need to carry around an ink bottle as well: the stylographic pen soon became the most widespread handwriting implement, and remained so for more than half a century. In 1940 it was replaced by the ballpoint pen, patented by László and György Bíró, which distributes ink using a small metal sphere that rotates on its own axis and can write for months without being refilled.

The fact is that only the nib will let you obtain a result similar to the examples you are about to see: with a stylographic pen or a ballpoint you will lose the magic of the alternation of thin and thick lines. You will still acquaint yourself with scripts and beautiful writing, but you will not be able to regulate the thickness of the line. With the nib, on the other hand, it is all a matter of pressure: you will draw an upstroke without pressing, then a downstroke squeezing and opening the line; you will go up quickly and lightly, coming down more slowly and broadening the mark. 'M' and 'n' are a sinuous dance, a triumph of harmony.

It is not difficult to master the use of the nib: whole generations of students have managed to do it. Once you have understood how to regulate the amount of ink, the only obstacle you encounter will be the paper: when you draw an upstroke, you will not feel the nib slipping as a pen would do, but scratching slightly. It is encountering resistance, which you will have to overcome firmly, but without pressing, to avoid getting stuck and spreading drops of ink.

Some advice, should you decide to buy a nib:

Except for professional nibs, they are all more or less equally good, so the final result will depend on your hand more than anything else. They come in different degrees of hardness: the harder the nib, the thinner the line will be; the softer it is, the broader the line will be. If it is the first time you have approached calligraphy, I would recommend a soft nib: opening easily, it will give you a better idea of how to regulate the pressure to obtain thin and thick marks.

To write, you have to put it in a penholder. Commercially, there is a broad choice of colours and materials: pick them up in your hand and choose the one you feel most at

ease with, bearing in mind that for the purposes of this book you won't need a super-professional piece of equipment.

Then put the nib in the holder using a piece of soft paper to avoid cutting yourself. One shortcut before you start working: every nib is sold with a thin layer of grease on the surface that prevents it from rusting, and thus has to be removed. We copyists clean it off with paper and put it in our mouths, washing it away with our saliva; but given that you are not familiar with this gesture, if you don't want to hurt yourself you can warm it up slightly with a lighter (but take care not to leave it close to the flame for too long).

Now you can dip it in the ink. Don't be afraid of picking up too much, because before bringing it to the paper you will always have to remove the excess in the ink bottle. After a few lines you will have worked out how to regulate the amount.

Inks

One of the advantages of writing with a nib is to be able to enjoy the smell of the ink: vivid, strong and penetrating, it won't let you forget that you are dedicating yourself to something very concrete, and it will help you to concentrate on the page.

The most widespread colour is black, but of course you can use whichever colour you like: nothing will change, whether you choose blue, red, sepia or green. The inks I suggest that you use to write on the paper of this book are Ecoline, but you can also use more common and equally trustworthy brands like Pelikan, Parker or Rubinato.

These are all quite durable inks: I can maintain almost without fear of denial that anyone finding this book in a hundred years could admire your progress in the ancient art of calligraphy.

If technical developments in writing instruments have made them more practical, developments in the formulas of ink have been aimed at finding a balance between durability and expense, since the basic components are anything but convenient. According to a medieval legend, around the year 1000, given the large amount of ink used by copyists (several litres a day, thousands in a year), the alchemists at the abbeys tried to experiment with cheaper formulas. One of these seemed to give good results, and therefore was

adopted. At a distance of a thousand years, however, we have noticed that some of the writing done with the new formula is fading: the ink did not penetrate the parchment but crystallised on the surface, so a slight scratch can make it disappear. One of the missions of contemporary restorers is to fix these texts, to avoid their being lost forever. Otherwise, manuscripts copied before the year 1000 appear remarkably stable and are practically as intact as when they were written.

How long does ink last?

To establish how long an ink will last you can do a test.

Take an ink and draw long lines on a sheet of paper, and then divide it in half. Date both parts: keep the first in ideal conditions of light and humidity, and expose the second to sunlight. Depending on the level of deterioration calculated by one month, two and so on, and compared with the first part kept away from direct sunlight, you can predict the durability of ink. Some formulas used currently, subjected to these tests, have shown an ability to last for over five hundred years.

The greatest mystery concerns red inks. In past centuries it was considered the most precious colour, and in fact it was used to give the imperial imprimatur to official documents. Given the great importance of this guarantee, the main composition of red ink was kept secret and known only to the copyists with the responsibility of printing royal seals. Even now we don't know exactly what elements it contained: based on the knowledge of the time we can say with relative certainty that it contained cinnabar (mercury sulphide), or minium (lead oxide), but what else? No copyist or laboratory managed to reproduce that imperial red until a few decades ago, when acrylic inks made it possible to produce a formula with a very similar tone, which has already enjoyed more than two hundred and fifty years of stability.

Scriptorium

You have now reached the practical part of the book.

Like copyists, you will start trying to find your rhythm and bring order to your writing by drawing straight lines on a lined notebook (school textbooks are fine for this). These straight lines, capital 'I's, all have to be the same height and equidistant (4–5 mm). After a few pages you will notice that as you find your rhythm all the marks you make will be straight and at the same distance from one another.

At this point you will be able to move on to study the upper- and lowercase alphabet of the English cursive that I've prepared you for.

Before writing a letter, take some time to study the journey that your nib will have to travel on the paper, both up and down. Not all letters are the same: some (like 'a') require two lines, others (such as 'c') only one; some will be intuitive (like 'p'), others less so ('k,' for example). In the panel that you will find in the pages that follow, for each letter I have indicated with an arrow the direction of each single line. Follow the instructions with your eye, then try them out. The first few times you won't feel at ease, but remember that copyists take months to become familiar with writing: you can't expect to obtain a good result straight away. Give yourself time to memorise the gesture, to familiarise yourself with the resistance that you will encounter on the paper, and identify your writing rhythm.

When you have practised with single letters you will be able to work on words.

The book contains guidelines which will help you to respect the standard slope of English cursive (55°) and vertical spacing, giving the correct length to the ascenders and descenders, and avoiding overlaps.

How to write each letter of the alphabet in cursive script

A ȯı→a *J B*→*B* *b*

C *c*∴*c* *D* ȯl→d

E *e* *J*→*F* *f*

G→*G* ȯj→g *H* *h*→*h*

\mathcal{I} i \mathcal{J} j

\mathcal{K} \mathcal{K} k k-k \mathcal{L} l

\mathcal{M} m-m \mathcal{N} n-n

\mathcal{O} o \mathcal{P}-\mathcal{P} p-p

\mathcal{O}-\mathcal{Q} q \mathcal{R}-\mathcal{R} r

\mathscr{S} $s \cdot s$

\mathscr{T} $t \cdot t$

\mathscr{U} $u \cdot u$

\mathscr{V} v

\mathscr{W} $v \cdot w$

\mathscr{X} $x \cdot x$

$\mathscr{Y} \cdot \mathscr{Y}$ $y \cdot y$

$\mathscr{Z} \cdot \mathscr{Z}$ z

Some details make the writing ugly, so I advise you to pay particular attention to the slope (particularly in the ascender), and the spaces between the letters (trying to avoid 'concertina words,' with some letters very close and others very far away) and between the words, which should be detached from one another by the space of an 'n.'

Remember that for me it's less important that you write very well than that you write and that while you do it you are emotionally involved. Only that way can you realign body, mind and spirit, and raise your eyes towards new horizons that life, always generous, offers you.

 Now close your eyes.

 Take a deep breath through your nose. Two or three times.

 Allow yourself to be filled with a sense of peace.

 Enjoy the enthusiasm you are feeling: you are about to have a new experience!

 Open the book. Sit comfortably, straighten your back and position the book in front of you.

 And now, turn the page.

Good luck!

Màlleus

\mathcal{N}

n

\mathcal{V}

v

Love

Soul

Harmony

Beauty

Wellbeing

Calm

Change

Body

Heart

Discipline

Energy

Essential

Being

Strength

Joy

Gratitude

Grace

Freedom

Light

Meditation

Nature

Peace

Words

Thoughts

Stillness

Silence

Spirit

Unity

Universe

Life

Carpe diem

Know thyself

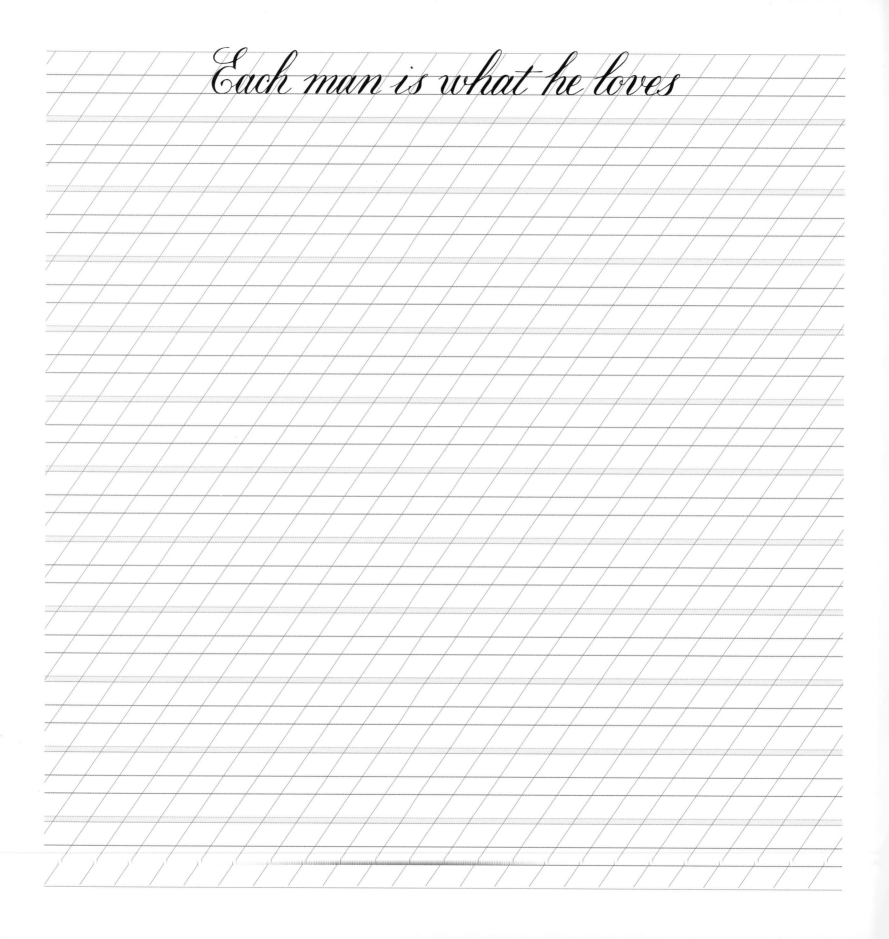

Each man is what he loves

Silence is a gift

Find your rhythm

Dance with words

Free your power

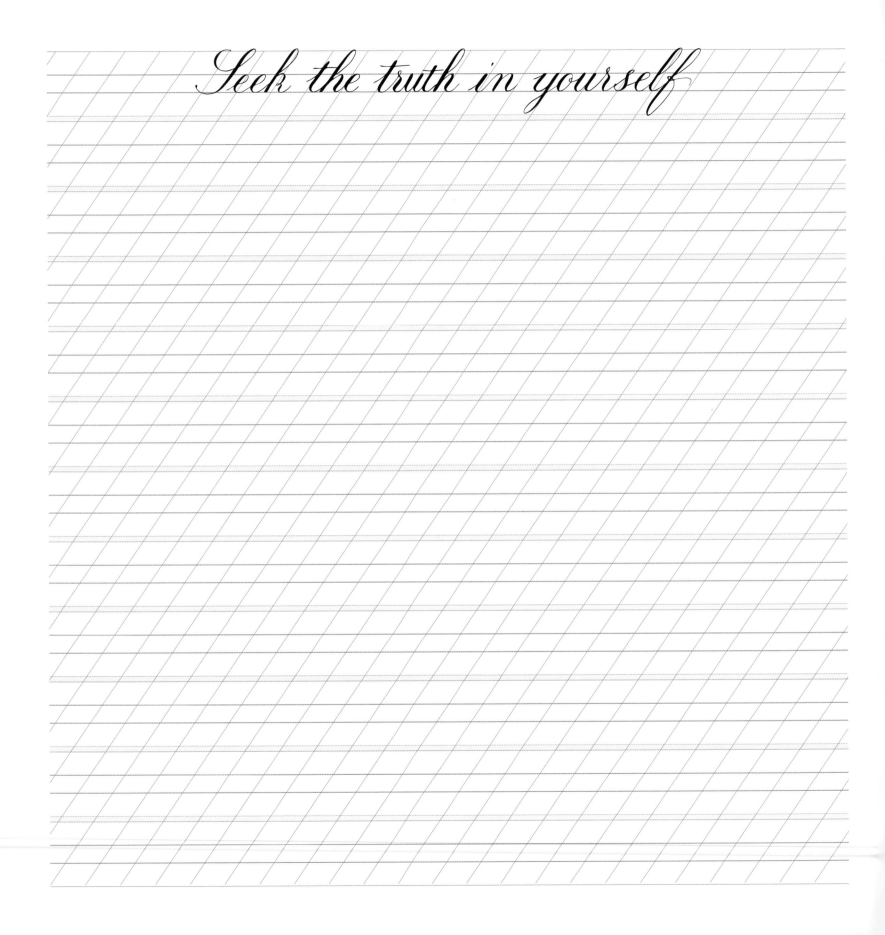

Seek the truth in yourself

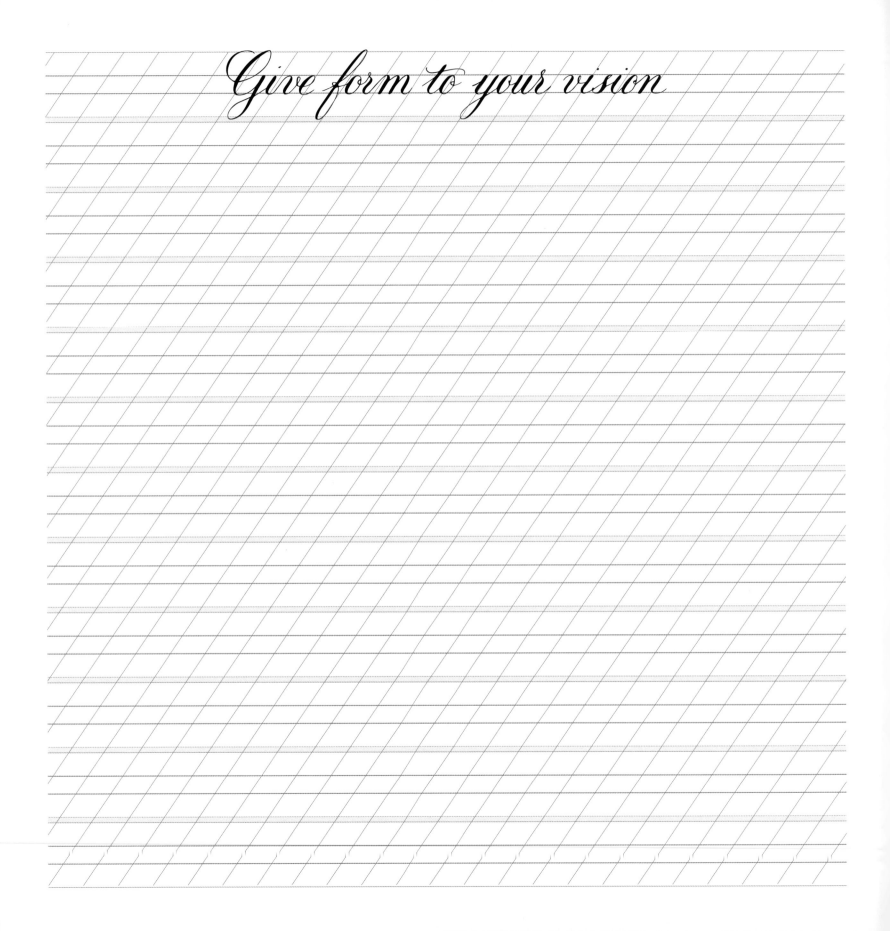

Give form to your vision

Allow yourself to change

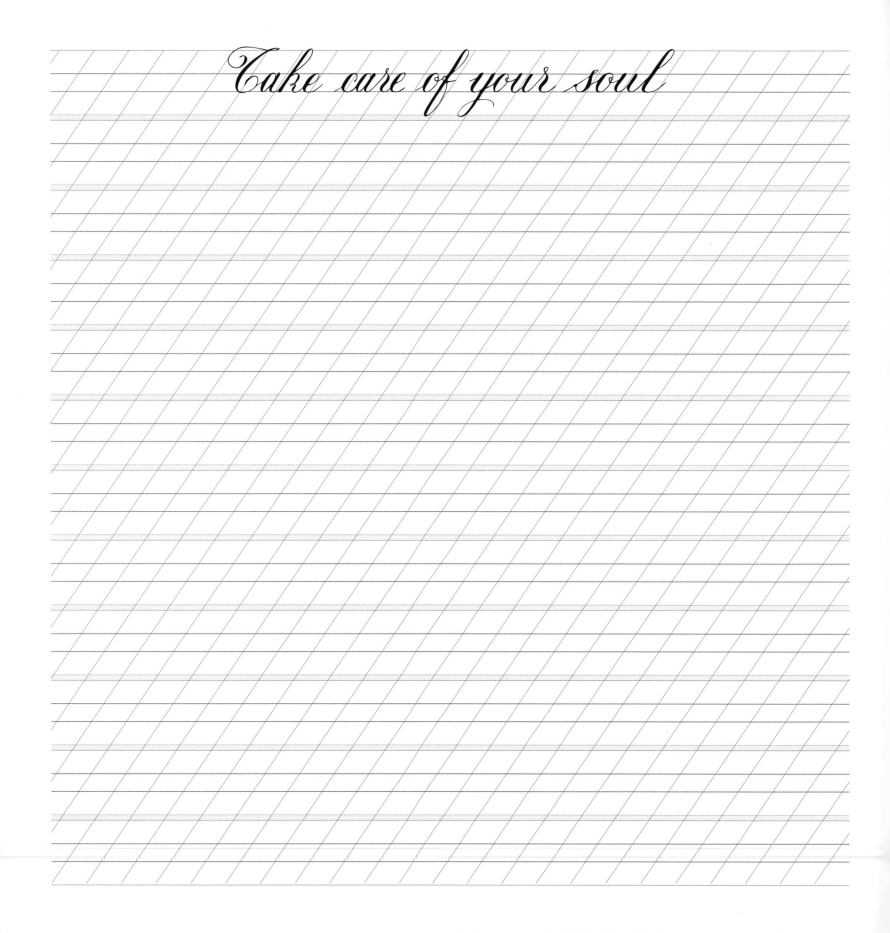

Take care of your soul

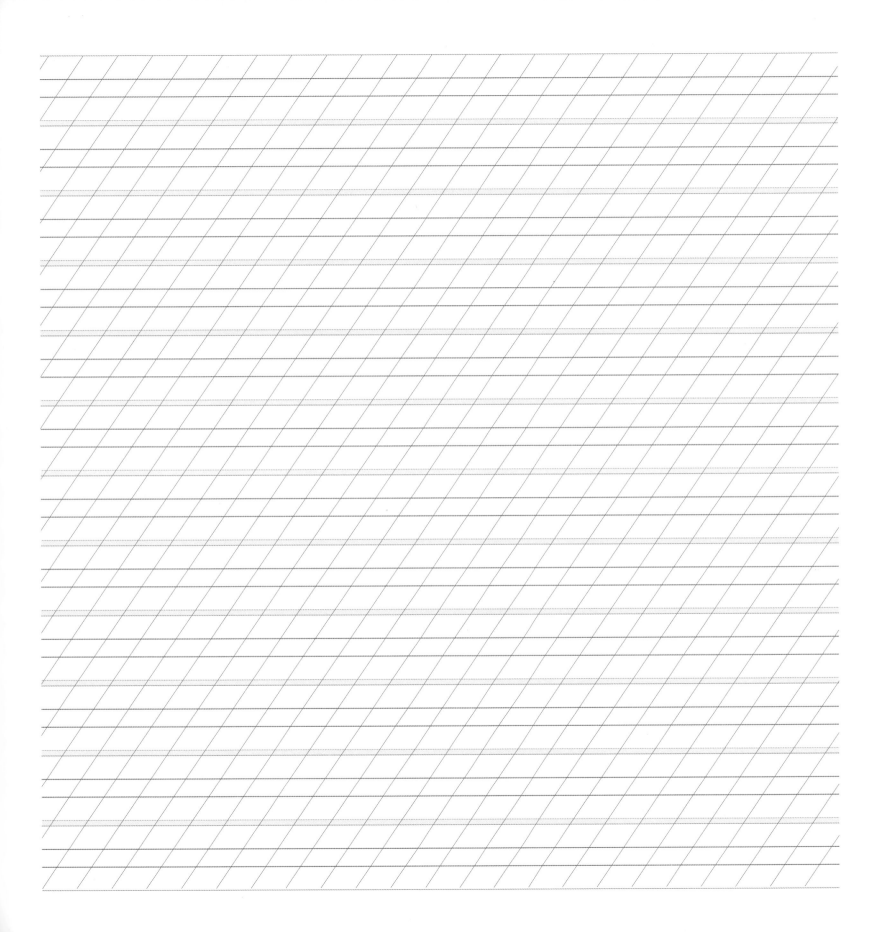

It is love alone that counts

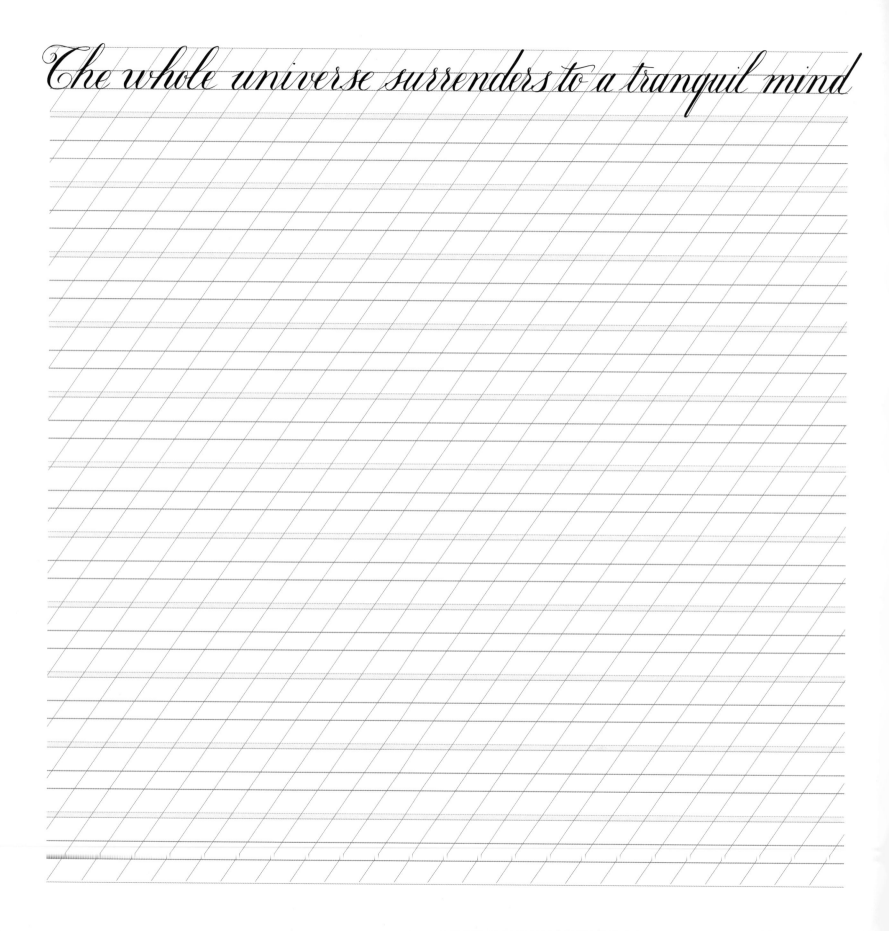

The whole universe surrenders to a tranquil mind

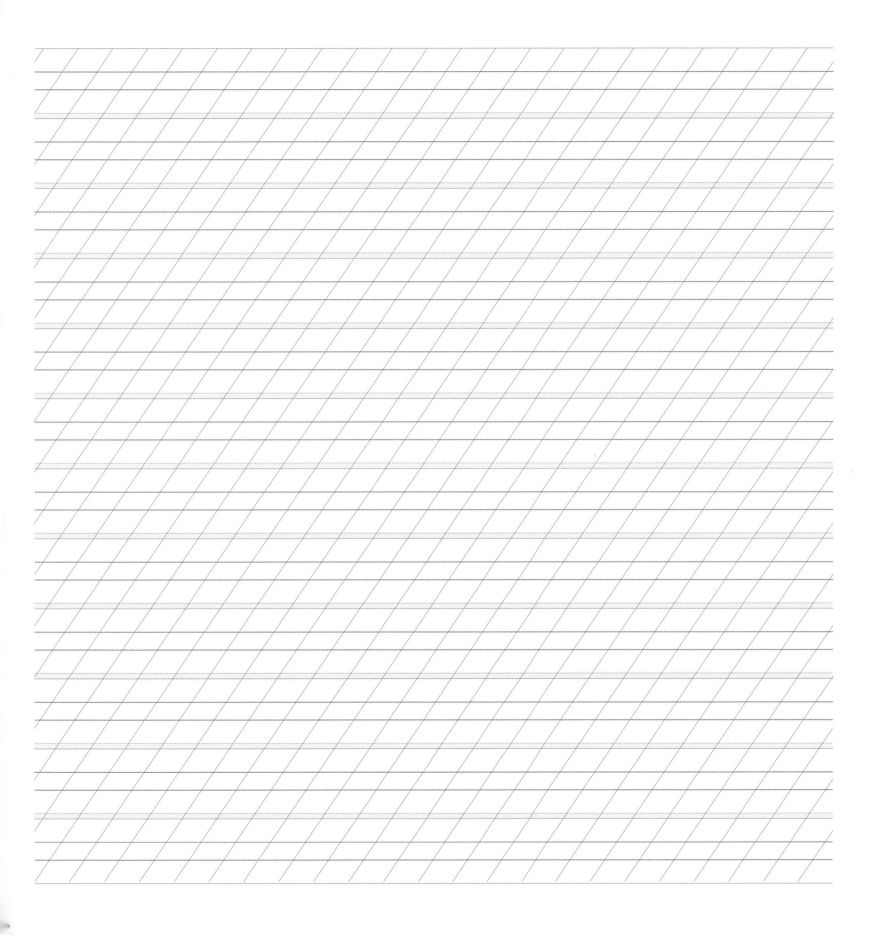

In this immensity my thinking drowns;
and sweet it is to be shipwrecked in this sea

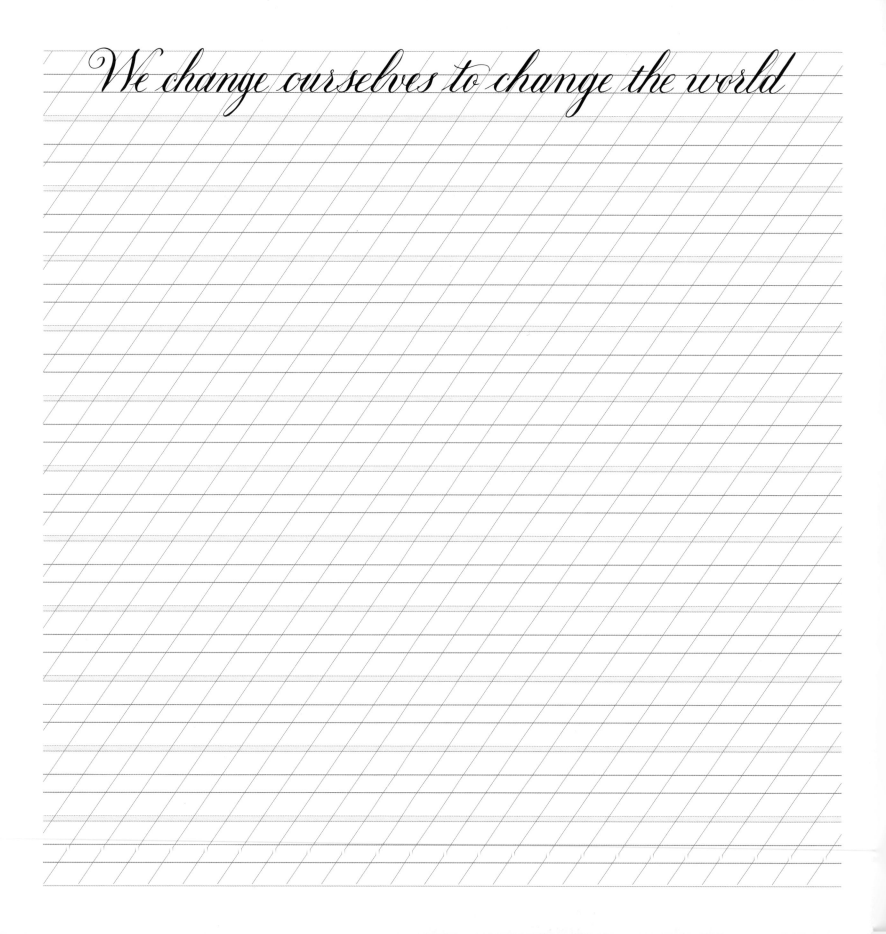

We change ourselves to change the world